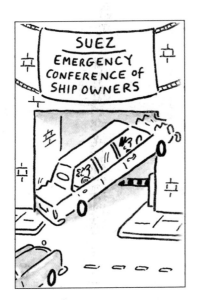

THE BEST OF
MATT
2021

MATTHEW PRITCHETT

studied at St Martin's School of Art in London and first saw himself published in the *New Statesman* during one of its rare lapses from high seriousness. He has been the *Daily Telegraph*'s front-page pocket cartoonist since 1988. In 1995, 1996, 1999, 2005, 2009 and 2013 he was the winner of the Cartoon Arts Trust Award and in 1991, 2004 and 2006 he was 'What the Papers Say' Cartoonist of the Year. In 1996, 1998, 2000, 2008, 2009, 2018 and 2019 he was the *UK Press* Cartoonist of the Year and in 2015 he was awarded the Journalists' Charity Award. In 2002 he received an MBE.

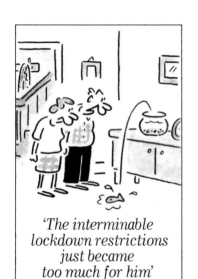

'The interminable
lockdown restrictions
just became
too much for him'

The Daily Telegraph

THE BEST OF

MATT

2021

SEVEN DIALS

An Orion Paperback

First published in Great Britain in 2021 by Seven Dials
A division of the Orion Publishing Group Ltd
Carmelite House
50 Victoria Embankment
London
EC4Y 0DZ

A Hachette UK Company

10 9 8 7 6 5 4 3 2 1

ISBN mmp: 978 1 4091 9150 6
ISBN ebook: 978 1 4091 9151 3

Printed in Italy by Elcograf S.p.A

The Orion Publishing Group's policy is to use papers that are natural,
renewable and recyclable products and made from wood grown in
sustainable forests. The logging and manufacturing processes are expected
to conform to the environmental regulations of the country of origin.

www.orionbooks.co.uk

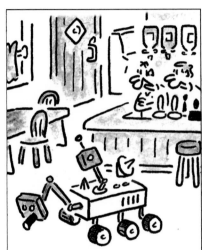

'I ordered it from NASA.
I'm told there might have
been life here once'

THE BEST OF

MATT

2021

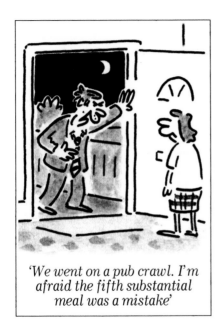

'We went on a pub crawl. I'm
afraid the fifth substantial
meal was a mistake'

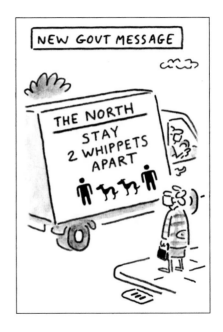

New Rules

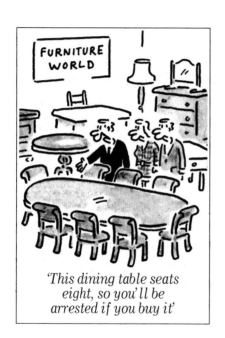

'This dining table seats
eight, so you'll be
arrested if you buy it'

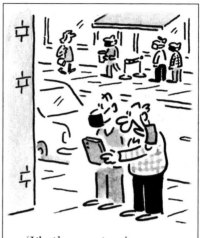

'It's the new tracing app.
It tells me if I'm near
anyone who understands
the latest rules'

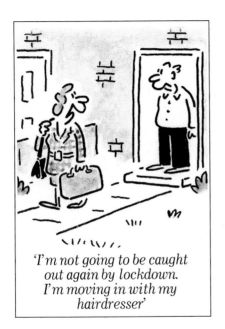

'I'm not going to be caught out again by lockdown. I'm moving in with my hairdresser'

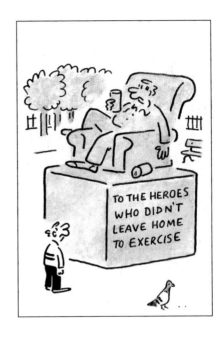

TO THE HEROES WHO DIDN'T LEAVE HOME TO EXERCISE

New Rules

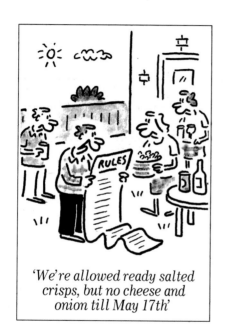

'We're allowed ready salted crisps, but no cheese and onion till May 17th'

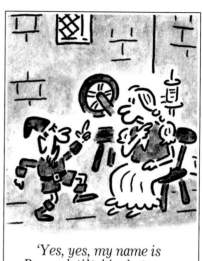

'Yes, yes, my name is Rumpelstiltskin, but now can you tell me the latest festive Covid rules?'

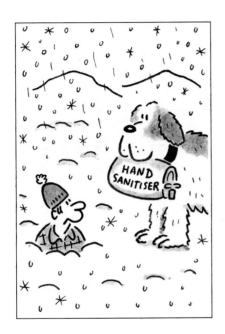

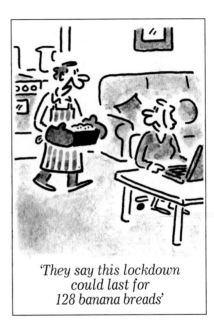

'They say this lockdown
could last for
128 banana breads'

New Rules

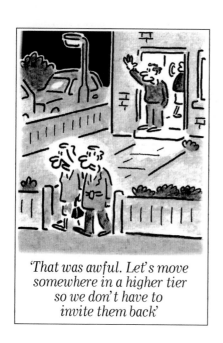

'That was awful. Let's move somewhere in a higher tier so we don't have to invite them back'

'Free range? What rubbish! This area is in Tier 3; we can't even go to the pub'

Different tiers ... different rules

'Time, gentlemen, please'

No fans allowed

'It's so depressing. I could be stuck in a bunker, swearing at my golf ball and trying to snap my club in half'

'I've laid down a case of vintage sanitiser for when my daughter's wedding can finally go ahead'

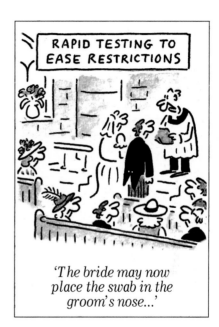

'The bride may now place the swab in the groom's nose...'

'And question six is: Are
pub quizzes still allowed?'

'The problem with restrictions is that some politicians don't know when they've had enough'

'It's 10pm, gentlemen, please. Haven't you got illegal raves to go to?'

'I'm making Christmas plans. Are we not coming to you, or are you not coming to us?'

'This isn't easy for me to say,
but I'm afraid you're not
in my Christmas bubble'

'We can spend Christmas
day with our loved ones – the
supermarket home delivery
driver and your hairdresser'

New Rules

GOOD KING WENCESLAS

'Yonder peasant, he's not
from Tier 4 is he?'

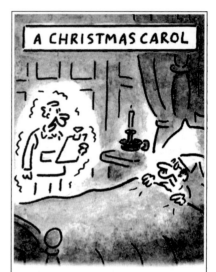

A CHRISTMAS CAROL

'I'm the Ghost of Lockdown
Restrictions Yet to Come'

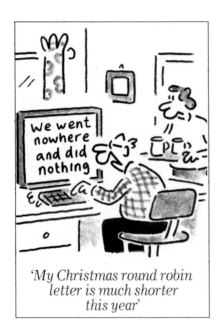

'My Christmas round robin
letter is much shorter
this year'

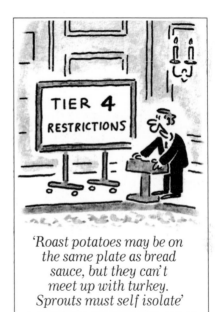

'Roast potatoes may be on
the same plate as bread
sauce, but they can't
meet up with turkey.
Sprouts must self isolate'

'I hear there's a 29-year
waiting list if you put
your name down
for a Covid test'

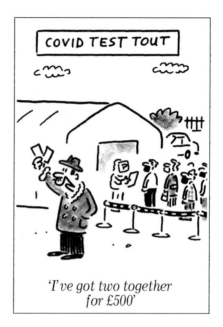

'I've got two together
for £500'

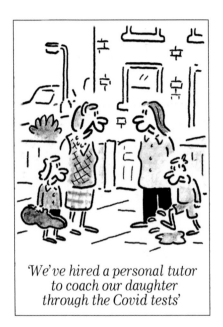

'We've hired a personal tutor
to coach our daughter
through the Covid tests'

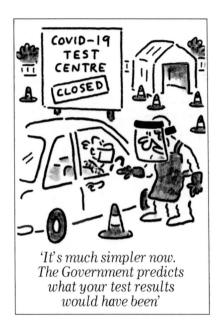

'It's much simpler now.
The Government predicts
what your test results
would have been'

GCSE results chaos

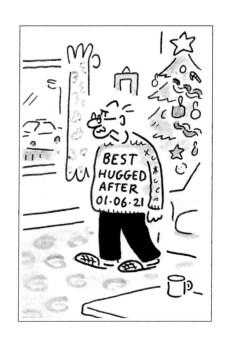

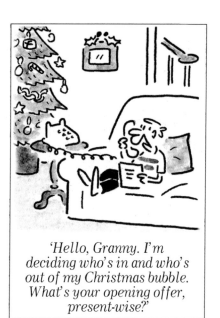

'Hello, Granny. I'm deciding who's in and who's out of my Christmas bubble. What's your opening offer, present-wise?'

'These Covid restrictions are infuriating. I just want to be able to have a Brexit row with my grandchildren'

'They say hugging your grandchildren carries no risk, but sometimes the little blighters wipe their noses on your jacket'

'Are we nearly there yet?
... Are we nearly there yet?'

'Your teachers want you
to attend summer school.
They estimate that you've
missed up to 20 detentions'

'I hate these primary school face masks. I've brought home the wrong child again'

'We'll accept mock exam results, predicted grades, or a recent horoscope'

Vaccine roll out

'We need to act fast.
First, let's move February
to the end of the year'

'Does this count
as a vaccination?'

Government targets

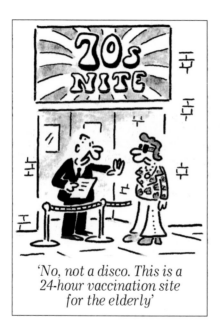

'No, not a disco. This is a
24-hour vaccination site
for the elderly'

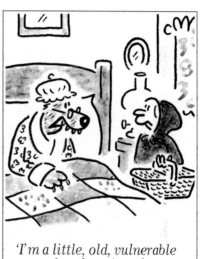

'I'm a little, old, vulnerable
grandmother. Any chance
you could get me the
Pfizer vaccine?'

Vaccine roll out

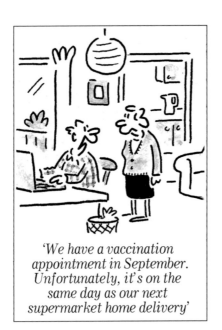

'We have a vaccination appointment in September. Unfortunately, it's on the same day as our next supermarket home delivery'

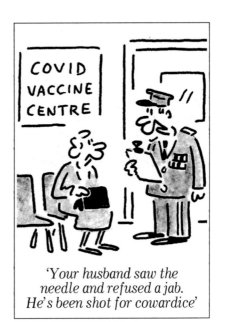

COVID VACCINE CENTRE

'Your husband saw the needle and refused a jab. He's been shot for cowardice'

Army steps in

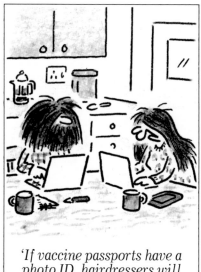

'If vaccine passports have a photo ID, hairdressers will have to open first'

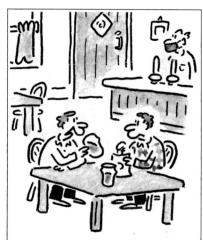

'I suffered an unpleasant side effect after my second jab – I was asked to go back to the office'

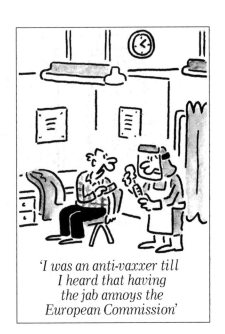

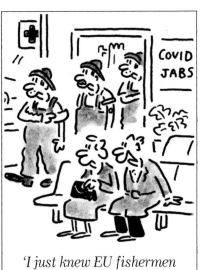

'There's some corner of a foreign field that is for ever my AstraZeneca jab'

'We're making Dunkirk 2. The Little Ships go to rescue our vaccines'

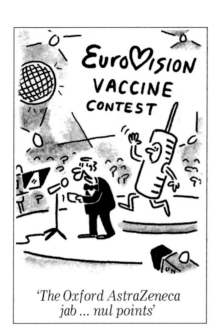

'The Oxford AstraZeneca
jab ... nul points'

'Did you hear that? I think
Ursula von der Leyen is
downstairs helping herself
to my stockpile of loo rolls'

'Is this vaccine from India? I don't like anything too spicy'

'We're working on our own vaccine. You still get Covid-19, but you can run 100m in under 9 seconds'

Covid variants

'I think I preferred
The Garden of England'

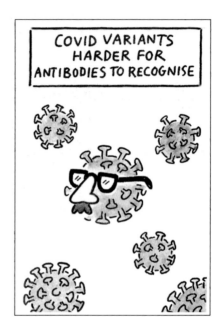

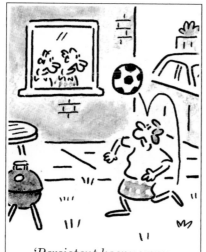

'Persistent keepy uppy.
That's a definite symptom of
the Brazil variant of Covid'

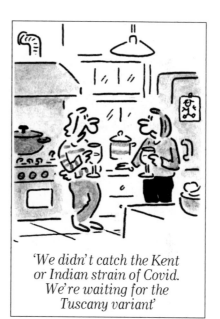

'We didn't catch the Kent
or Indian strain of Covid.
We're waiting for the
Tuscany variant'

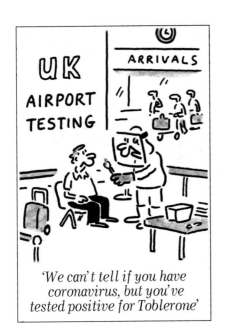

'We can't tell if you have coronavirus, but you've tested positive for Toblerone'

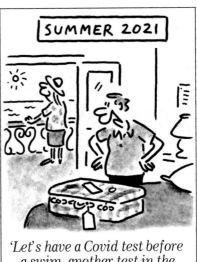

'Let's have a Covid test before a swim, another test in the bar and then a pre-dinner test on the terrace'

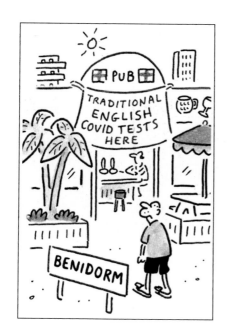

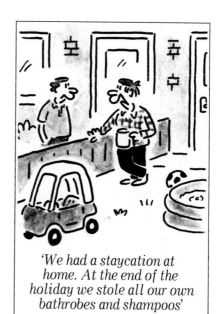

'We had a staycation at home. At the end of the holiday we stole all our own bathrobes and shampoos'

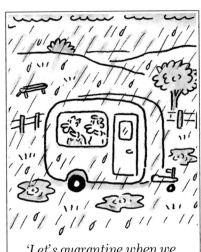

'Let's quarantine when we get home so the neighbours think we've been somewhere exotic'

'It was a holiday romance. I tried to fly to a hot, sunny beach and he fined me £5,000'

'We have a favourite hotel
in Spain. We cancel the
same two weeks in
August every year'

'I'm confused now. Are you
going to Portugal
next week, or not?'

'You've landed on one of my quarantine hotels. You have to stay there for ten days'

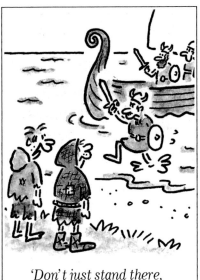

'Don't just stand there, build a quarantine hotel'

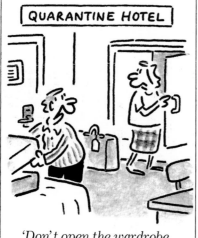

'Don't open the wardrobe straight away, we'll have nothing to look forward to in the next ten days'

'You're dreaming of ten days in a quarantine hotel on your own, aren't you?'

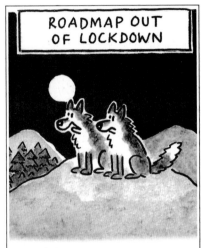

ROADMAP OUT
OF LOCKDOWN

'Apparently, there's a crazy
plan to reintroduce humans
into parts of the UK'

'They also say a watched
lockdown never, ever,
ever ends'

'I'm afraid things have taken a worrying turn. The virus is now trying to lull us into a false sense of security ...'

Easing restrictions

'I'll have my usual — whatever that was'

PUB

MON 17TH
5 – 6 PM
HAPPY HOUR

6 PM. NEXT
LOCKDOWN
BEGINS

BAR

'I can't remember if I'm
worrying about work on
my day off, or skiving
on a work day'

'We've had nearly a year of
lockdowns. When this
is over, let's never go
for a walk again'

'When the circus reopens
do you intend to go on working
from home?'

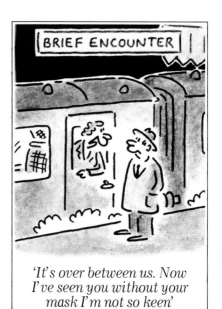

'It's over between us. Now
I've seen you without your
mask I'm not so keen'

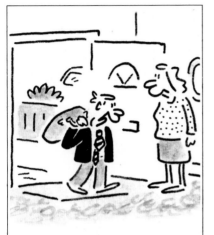

'I was sent home from school
because my imaginary
friend tested positive
for Covid'

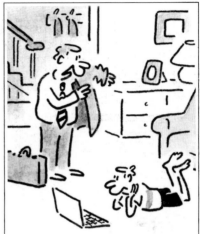

'Cheer up. Very soon it will
be the end of not going to
school and the start of
not going on holiday'

Dominic Cummings

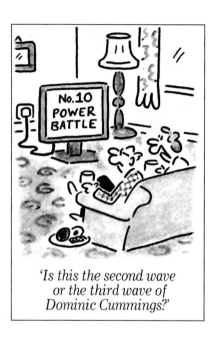

'Is this the second wave
or the third wave of
Dominic Cummings?'

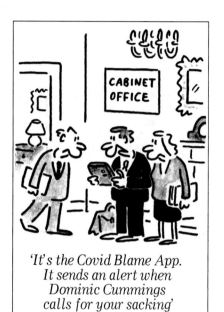

'It's the Covid Blame App.
It sends an alert when
Dominic Cummings
calls for your sacking'

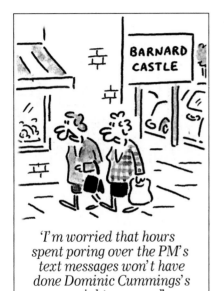

'I'm worried that hours spent poring over the PM's text messages won't have done Dominic Cummings's eyesight any good'

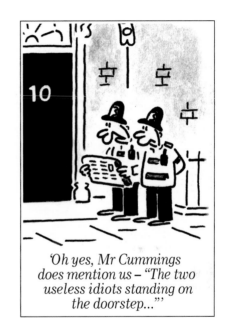

'Oh yes, Mr Cummings does mention us – "The two useless idiots standing on the doorstep..."'

Wallpaper and red wall

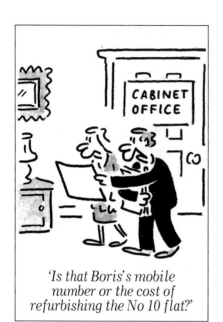

'Is that Boris's mobile
number or the cost of
refurbishing the No 10 flat?'

'They want the kitchen in
this grey called Chatty Rat,
and the hall in this red
called Dominic's Fury'

Tories win Hartlepool

Post Brexit UK

Delays at Dover

'The Government believes that EU treaties should be honoured for as long as it takes to sing Happy Birthday twice'

The Northern Ireland protocol

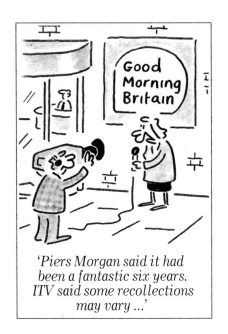

Piers Morgan quits

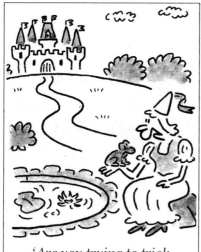

'Are you trying to trick
me into giving you an
interview, Mr Bashir?'

'Is that Panorama?
Could you forge some
bank statements to make
it look like I've paid
my TV licence?'

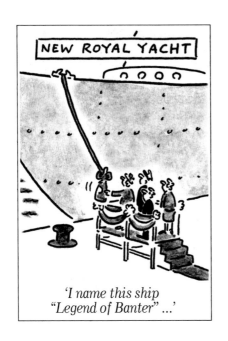

'I name this ship
"Legend of Banter" ...'

'No military uniforms?
I didn't get the memo'

Harry returns for Prince Philip's funeral

'And if it's a girl
we're going to call it
Her Majesty the Queen'

Baby Lilibet

QUEEN'S
CHRISTMAS
MESSAGE
2021

'The following programme
contains strong language
from the start'

'It's nearly harvest time,
when Chinese companies
gather in all our data'

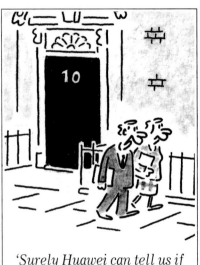

'Surely Huawei can tell us if
the Russians are trying to
steal our Covid-19 vaccine'

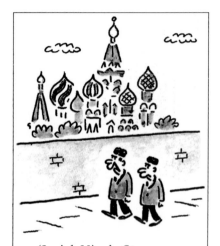

'I wish Nicola Sturgeon
would consult us before
calling for a second
referendum – it's a lot of work'

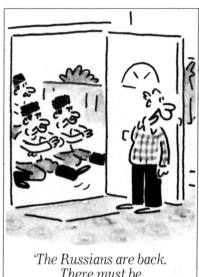

'The Russians are back.
There must be
another election'

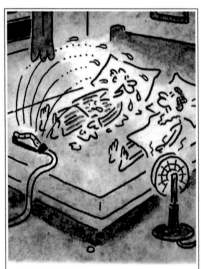

'You've got the fan, so I'm having the sprinkler'

'Hello, Test and Trace? Do you know the whereabouts of my shed roof?'

'I was worried that he might have historic links to the slave trade'

STORM CHRISTOPH

'The tree in our front garden is no longer socially distanced from your car'

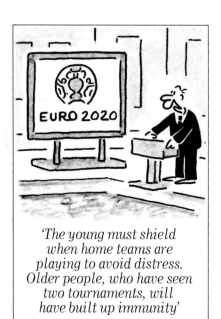

'The young must shield
when home teams are
playing to avoid distress.
Older people, who have seen
two tournaments, will
have built up immunity'

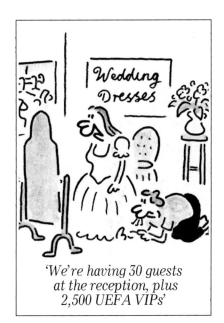

'We're having 30 guests
at the reception, plus
2,500 UEFA VIPs'

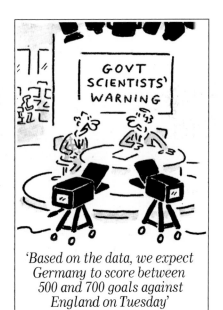

'Based on the data, we expect
Germany to score between
500 and 700 goals against
England on Tuesday'

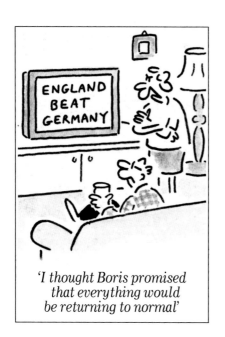

'I thought Boris promised
that everything would
be returning to normal'

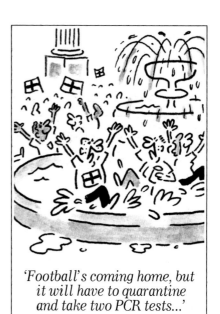

'Football's coming home, but
it will have to quarantine
and take two PCR tests...'

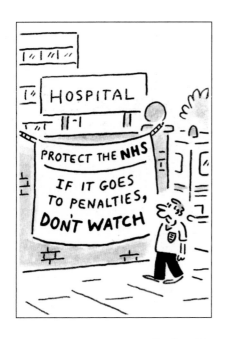

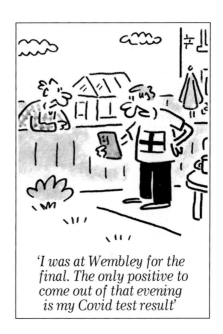

England lose to Italy in the final

And finally...

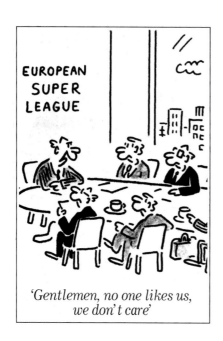

Breakaway league proposal

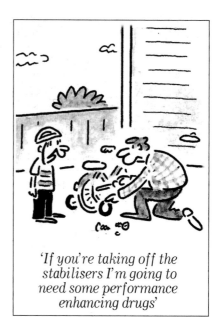

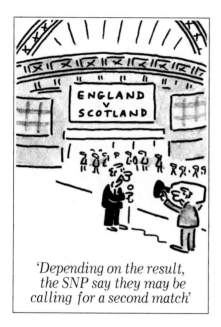

'Depending on the result, the SNP say they may be calling for a second match'

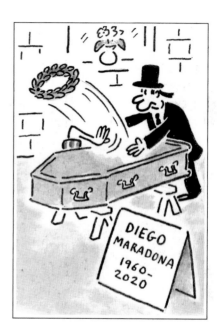

'The hand of God'

And finally...

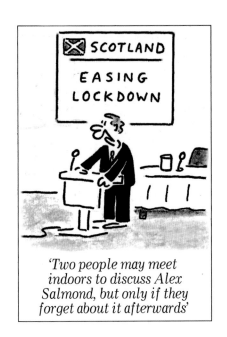

'Two people may meet indoors to discuss Alex Salmond, but only if they forget about it afterwards'

Alex Salmond trial

'My son's doing very well
at university. His tutor
says he's a super-spreader'

'Jeff Bezos is standing down
so we're having a
whip-round for him'

And finally...

And finally...

'That's not how you take a Covid swab'

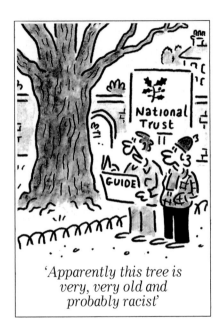

'Apparently this tree is very, very old and probably racist'

Minister resigns

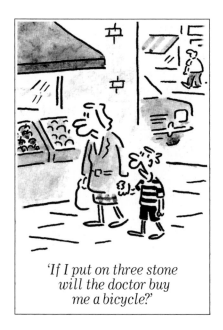

'If I put on three stone will the doctor buy me a bicycle?'

Plans to tackle obesity

DRY JANUARY CERTIFICATE

'It's a forgery. I bought it online for £50'

And finally...

'It's this damned Jersey fishing war. I'm afraid you've been called up'

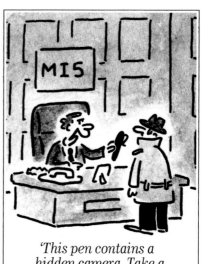

'This pen contains a hidden camera. Take a photo of your lunch and then post it on social media'

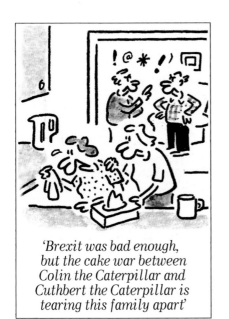

'Brexit was bad enough, but the cake war between Colin the Caterpillar and Cuthbert the Caterpillar is tearing this family apart'

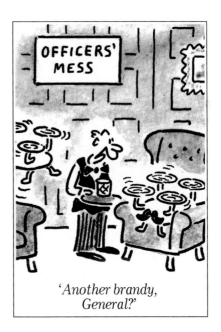

'Another brandy, General?'

Modern military

And finally...

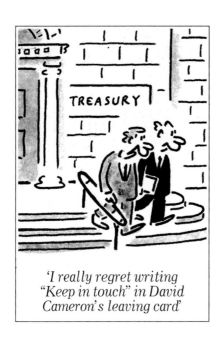

'I really regret writing "Keep in touch" in David Cameron's leaving card'

Lobbying scandal

'We have orders to fire if anyone attending the G7 in Cornwall puts clotted cream on their scone before the jam'

'The new trade deal means that Australian sheep can come to the UK and beat us at cricket'

'After isolating with his dog Dilyn, the PM has now tested positive for kennel cough'

And finally...

STONEHENGE TRANSPORTED FROM WALES ?

Dear Sir,
Your stone circle will be delivered between 3,000BC and 2,000BC. Please make sure you are in to sign for it.

'Your car has tested positive for diesel and must now self-isolate for ten years'

'My new car is electric.
It has nearly enough range
to drive to the nearest
charging point'

And finally...

RETIREMENT HOME
FOR POLITICIANS
WHO USED TO SAY
THEY WERE GOING
TO REFORM
SOCIAL CARE

*'A fire at the GP surgery?
We're only doing online
appointments at the moment'*